Making It Real

Introduction by Luc Sante
Essay by Guest Curator Vik Muniz

A traveling exhibition organized and circulated by
Independent Curators Incorporated, New York

The exhibition, tour, and catalogue are made possible, in part, by grants from The Lannan Foundation and the National Endowment for the Arts.

Independent Curators Incorporated, New York, is a non-profit traveling exhibition service specializing in contemporary art. ICI's activities are made possible, in part, by individual contributions and grants from foundations, corporations, and the National Endowment for the Arts.

Itinerary*

The Aldrich Museum of Contemporary Art
Ridgefield, Connecticut
January 19 - April 20, 1997

The Reykjavik Municipal Art Museum
Reykjavik, Iceland
October 18 - November 23, 1997

Portland Museum of Art
Portland, Maine
January 22 - March 22, 1998

Bayly Art Museum
University of Virginia
Charlottesville, Virginia
September 18 - November 15, 1998

*As of November 1996

Lenders

Albright-Knox Art Gallery, Buffalo, New York

Bonni Benrubi Gallery, New York

Janet Borden, Inc., New York

James Casebere

Catherine Chalmers

Olivier Renaud-Clement

CRG Gallery, New York

Thomas Demand

Philip-Lorca diCorcia

Peter Garfield

Tom Gitterman

Charles Griffin

Luhring Augustine, New York

Brian McCarty

Laurence Miller Gallery, New York

Metro Pictures, New York

Margaret Murray Fine Arts, New York

Warren Neidich

PaceWildensteinMacGill, New York

Tom Peters

Alan Power

The Progressive Corporation, Cleveland, Ohio

Max Protetch Gallery, New York

Refco Group, Ltd., Chicago

Kenneth H. Shorr

Laurie Simmons

Sonnabend Gallery, New York

Bernard Voïta

Wooster Gardens/Brent Sikkema, New York

Zabriskie Gallery, New York

Table of Contents

Acknowledgments

We live in an era when a myriad of images constantly bombard our sensibilities—through television, advertising, computers, and a variety of communication media—and we repeatedly question the realities on which those images are based. What better time to examine how artists playfully manipulate our sense of what is real and what is not. ICI is delighted to have guest curator Vik Muniz explore the particular genre of set-up photography in Making It Real.

Vik joins me in expressing gratitude to the artists and lenders who have made this exhibition possible and to the writer Luc Sante for his thoughtful introduction. This exhibition would not have been possible without generous grants from The Lannan Foundation and the National Endowment for the Arts, and additional funding from David Leigh. Their support is greatly appreciated.

To ICI's staff—Judith Richards, Ann Kone, Lyn Freeman, Jack Coyle, Alyssa Sachar, Kirsten Dieterich, Stephanie Spalding and Linda Obser—I express my sincere thanks for their efforts in organizing this exhibition. I would also like to thank each member of ICI's Board of Trustees—it is they who, through their continued commitment and dedication to our organization, have truly made this exhibition a reality.

Sandra Lang
Executive Director

Science and Fiction

by Luc Sante

For many people, photography is a bit like the religion in which they were raised: they once thought it was the rock of truth, then they got disillusioned, but they continue to attend, if only on holidays. Photography's claim on truth was long its major selling point, and the faith it fostered allowed all sorts of fibs and confections to slide by, mostly unquestioned. Such obvious—and oddly beautiful—grotesqueries as the "spirit" photographs of the nineteenth century may not have fooled all that many, but it was not until recent decades that more subtle photographic dissemblings became common knowledge: Alexander Gardner moving corpses around on Civil War battlefields to enhance his compositions, Edward S. Curtis persuading turn-of-the-century Native Americans to pretend they still lived and dressed like their ancestors, the captions that changed the meanings of famous pictures by Robert Capa and Arthur Rothstein. And now there is nobody who doesn't know about how seamless lies can be concocted from photographic odds and ends with the assistance of a computer.

Now that we know that photography is capable of deception we may be saddened, hardened, made wiser or more cynical, but at the same time we are freed, able to consider it as more than just a recording medium. Something similar must have happened on a rainy afternoon in the Paleolithic era, when one or more Neanderthals were struck by the idea that language could be used to express thoughts unsupported by known facts. This thunderbolt was perhaps the birth of commerce; the birth of fiction may have come a few—minutes? years? epochs?—later, when it occurred to someone that falsehood practiced without intending to dupe could cut a northwest passage to a greater truth.

Luc Sante is the winner of the 1989 Whiting Award and author of Low Life, Evidence, and (forthcoming) The Factory of Facts.

Fiction has of course been practiced by photographers for well over a century. Henry Peach Robinson was not intending to deceive when he used montage techniques to assemble complex tableaux with multiple sources of light, and neither was F. Holland Day when he photographed himself impersonating the crucified Christ. The former was competing with painting; the latter was too, with an additional bow to theater, in the context of a glaring thesis on the intersection of religion and sadomasochism. Both these ancestors have willy-nilly become our contemporaries, because we have over the intervening century learned to think of artificiality not as a dodge or a stopgap but as a desirable end in itself. I'll leave it to the others to attempt a definition of the mysterious portmanteau known as post modernism—suffice it to say that one of its components is a desire for supper-club magic as enacted by a prestidigitator who will show us exactly how the rabbit appears to come out of the hat. We want to be fooled and not-fooled in the same instance.

The artists in this show are a diverse bunch, but one of the qualities they share is a willed and knowing innocence. Through years and decades of art-world effluvia, of theoretical arguments and deconstructions and semantic shuffling, they have remained faithful to their very early aesthetic experiences. These include movies, television, pop-up books, optical illusions, dollhouses and toy-soldier deployments, science-fair exhibits and museum dioramas. None of them, I will venture to say, would regard the term "staginess" as an affront. They revel in minutiae and practical ingenuity. Most of them would probably pursue the look of grandeur on a budget even if their resources were unlimited, would prefer to be Georges Méliès than George Lucas. They have chosen photography because of its inherent bittersweet paradox, a paradox that goes a long way toward defining the moment, when ontological uncertainty has wafted out of the corridors of the philosophy department like an ambient fume and become part of daily weather. As the saying goes, all that was once directly lived has become mere presentation—or something like that.

Beyond these similarities, the artists span a wide range, from the jocose to the tragic, from the anecdotal to the near-abstract, from the recondite intellectual to the unmediated visceral, from the painstakingly illusionistic to the deliberately crude. This is perhaps a show that could only be put together right now, when their links have become apparent but before they have time to, as seems more than possible, each engender separate tendencies that will end up occupying future schools of taxonomists. By then, the average consumer of images may no more think of looking at a news photograph without critical doubt than today's movie audiences would leap out of the way of a shot of an onrushing train. By then the full irony of this show's title will have sunk in.

Making it Real

Life itself is not the reality. We are the ones who put life into
stones and pebbles.

<div align="right">Frederick Sommer</div>

<div align="right">**by Vik Muniz**</div>

The Good Picture

"Smile!" commanded the despotic man in the burgundy jacket. We obeyed immediately, only to be rewarded by the blinding light of a flash. At the age of four, I didn't question why I should smile without being happy. Apparently, neither did my parents. Smiling for a camera seems to be imbedded in the genetic coding: even the blind do it.

Looking at that impromptu portrait from Sears thirty years later, I am struck by the fact that we—my mother, my father, and I—are all smiling in ways we never did in life. Something had been altered; even my ugly orthopedic shoes, which I wore well after my thirteenth birthday, were nowhere to be seen. But somehow our smiles still manage to reveal the twelve hours a day my mother spent behind a switchboard at the phone company, the two jobs my father held as a waiter to support my grandparents and me, and my own confusion toward the world I was just beginning to know. Through the lie of the photograph, I can still discern the desires and intentions of my family as well as our striving to conform to the format of a portrait—to make the "good picture."

Since the earliest days of photography its development has been linked to increasing control of the photographic process as evidenced in the final print. Traditionally, the photographer concerned himself first and foremost with issues surrounding the quality of the image: ensuring that the subject be properly lit and arranged harmoniously within the frame, timing the picture to capture the best possible moment, and retouching any imperfections in either the negative or the subject's appearance.

Today, in the aftermath of significant breakthroughs in the field of digital imaging, the photographer's control over the image is potentially unlimited. This new development

Vik Muniz is an artist, writer, and associate editor of Blind Spot.

raises interesting questions. How will the way we look at photographs change? How can a photograph be trusted as a reliable picture of reality? And how will our memory of the past, which is so often buttressed by photographic images, be affected?

Whenever a powerful new technology has been introduced in the past, it has forced the re-examination of existing technologies and their power and purpose within society. In the nineteenth century, the advent of photography allowed painters to move away from "factual" representation, and to develop a more conspicuous style of execution. Surface and texture became important issues, brush strokes more signature-like; the painting's "truth" became embedded in its treatment of the subject, rather than in the subject itself. In a similar way, digital imaging has exposed long overlooked aspects of photography, forcing the medium to abandon all ambition toward either absolute truth or persuasive illusion, and to assume a more critical position. As a result, artistic photography has either become more casual (snapshots and unfinished-looking printing) or overtly staged in such a way that the viewer can trace the entire mechanism of representation in the image. This latter strategy, which allows for a greater degree of variety and complexity than the former, is the subject of this exhibition.

It is significant that this investigation of staged photography should occur at a time when technical developments in the field of digital imaging have ostensibly rendered pre-photographic fabrication completely obsolete. In the face of such sophisticated technology, set-up photography can be used as a critical tool to expose the photograph's illusion of reality. By choosing to fabricate their subjects and photograph them without much artifice, the photographers in this exhibition ultimately resurrect a nostalgic view of the photographic subject as a staged presentation.

Double Negatives

A kid I know was watching the Oscars. When the actor Christopher Reeve came on stage he said, "Everyone thinks this guy is Superman. I know who he really is. His real name is Clark something."

When an actor pretends he is someone other than his character, he reinforces the presence of his role with an act of false denial. The play within the play in <u>Hamlet</u>, for example, allows the truth to emerge. A similar thing happens when we attempt to photograph things that are in themselves representations of something. The simple exercise of discerning what is real from what is fake within an image makes us instinctively raise and lower, like an elevator, the grounds of our belief.

Since 1840, when Hipolite Bayard took an image of himself as a drowned man to protest France's failure to acknowledge his participation in the invention of photography, we have lived with the knowledge that photography does not always tell the truth. However, the eye takes enormous pleasure in being fooled and we have even developed a taste for such hoaxes. The joy we experience in looking at photographs of fabricated images—the Loch Ness monster for example—comes partly from the fact that while these images (whether you believe them or not) cannot prove the existence of this mythical creature, their utter audacity and

unreality has the peculiar effect of underscoring the reality of the world outside the photograph.

Although the tabloids that regularly feature such images are now produced by complex technological processes, most of their images still maintain a low-tech feeling: we can clearly discern the retouching, the intentional blur, the artificial materials employed to fabricate aliens, devils, and Elvis apparitions. These same imperfections, accidents and distortions have also become the semaphores of reality in today's set-up photographic representations.

Making It History

> The camera records what is focused upon the ground glass. If
> we had been there, we would have seen it so. We could have
> touched it, counted the pebbles, noted the wrinkles, no more,
> no less. However we have been shown again and again that
> this is pure illusion. Subjects can be misrepresented, distorted,
> faked. We now know it and even delight in it occasionally, but
> the knowledge still cannot shake our implicit faith in the truth
> of a photographic record.
>
> Beaumont Newhall, The History of Photography, 1964

During the early days of photography all studio photographs were necessarily ritualized and in this sense, set-up or fabricated. The sheer number of exposures necessary to create a satisfactory image required long, ceremonious preparation not only by the photographer but also by the subject, who had to "become" the image beforehand. Still-life vignettes needed to be carefully arranged, portrait subjects well combed and dressed in their finest attire. Some even wore perfume.

The introduction of the calotype, a technique developed in 1840 by the British mathematician, scientist, and linguist W.H.F. Talbot, opened a new era in the history of image taking and set-up photography. Although slightly more complicated to produce than the daguerreotype, the calotype allowed a great deal of post-photographic manipulation and, unlike the daguerreotype, enabled an infinite number of reproductions to be made from a single negative. Manipulation of the negative permitted the photographer a number of corrections and "enhancements" that would not be noticeable in the final print.

In order to advance the status of photography it became necessary to reinvent it as "art," and by the 1860s it was no longer enough that a photograph simply be well executed. One of the ways in which photographers transformed the medium was by creating pictorial allegories. Allegorical photographs can be traced back to 1843, when John Edwin Mayall of Philadelphia made a series of daguerreotypes to illustrate the Lord's Prayer. Later, during the Victorian era, the allegorical genre grew to embrace theatrical fabrications and dramatic lighting, and photographers began to expand their control over printing effects and manipulated negatives.

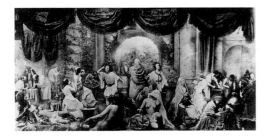

Figure 1: Oscar J. Rejlander, <u>The Two Ways of Life</u>, 1857. Albumen print. Courtesy George Eastman House, Rochester, NY, and The Royal Photographic Society, Bath

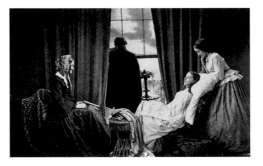

Figure 2: Henry Peach Robinson, <u>Fading Away</u>, 1858. Combination albumen print. Courtesy George Eastman House, Rochester, NY

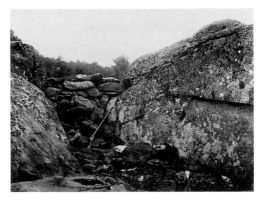

Figure 3: Alexander Gardner, <u>Home of a Rebel Sharpshooter</u>, 1863. Albumen print. Courtesy George Eastman House, Rochester, NY

Theater became the main subject for the most notable artists of this period, including Oscar G. Rejlander, whose highly elaborate photographs such as <u>The Two Ways of Life</u> (figure 1) often involved the assemblage of more than twenty negatives depicting epic moral tales. Henry Peach Robinson, a contemporary of Rejlander, illustrated Shelley's poem, <u>Fading Away</u> (figure 2), using a constructed image of a frail young lady on her deathbed (actually a healthy girl of about fourteen). Robinson's photograph profoundly shocked the Victorian public, who felt it in poor taste to represent a scene so painful to look at. However, paintings depicting far more painful subjects were commonly accepted at the time.

Photography's power to disturb and move public opinion was soon put to use in the coverage of the American Civil War. Fierce competition led photographers to enhance the shock value of their photographs. Even the dead were made to perform for the camera. Timothy O'Sullivan, for example, physically re-grouped scattered corpses to achieve the horrific atmosphere of <u>A Harvest of Death</u>. In Alexander Gardner's <u>Home of a Rebel Sharpshooter</u> (figure 3), the same dead soldier's body appears in several different settings. In a similar way, although for a different purpose, Edward S. Curtis would later photograph the same Native American in a variety of costumes as part of his survey on different Indian tribes.

The work of pictorialists F. Holland Day, Guido Rey and Richard Pollock propelled allegorical photography into the twentieth century. Day, a friend of Oscar Wilde's, gained notoriety through his dramatic re-enactment of the crucifixion (posing himself as Christ)

in <u>Study for the Crucifixion</u> (figure 4); Pollock and Rey devoted themselves to recreating scenes from famous Renaissance paintings.

By the turn of the century allegorical photography had gradually shifted its focus away from such complex fabrications and had begun to feature more mundane settings and scenes. But in the early 1900s the work of Photo-Secessionists such as Alfred Stieglitz marked a renewed emphasis on post-photographic techniques; for these practioners the effects obtained by toning, diffusing and texturing became as important as the subject.

With the emergence of photographers such as Paul Strand and Edward Weston in the 1920s, "straight" photography became the new artistic criteria. One outcome of its practice was the rise of a new puritanical attitude that effectively banned fabricated photography as the subject of serious artistic discourse until well into the 1930s.

One of the reasons behind the change of attitude toward photographic embellishment was the popularization of the halftone press, which finally enabled newspapers and magazines to illustrate their articles with photographs. Photography and text seemed to validate one another, fostering a subconscious belief in the veracity of the photographed event.

Paradoxically, while the lineage of straight photography can be traced back to the introduction of the halftone, the halftone also precipitated the birth of commercial photography; this in turn created a ready market for the manipulated images used to promote the new post-war consumer goods. As art historian Naomi Rosenblum notes, the idealized images commercial photography demanded "conflicted with the 'New Objectivity,' a philosophy that emphasized 'the thing itself.'"[1] In fact, most trickery used to produce commercial images aimed at the crafting of "perfect moments" that seemed natural and spontaneous. At the same time, Rosenblum observes, Bauhaus and Constructivist artists and photographers, in a utopian effort to make excellence available to all, proposed to wipe out distinctions between fine and applied art.[2]

Many outstanding photographers in the 1920s responded by ignoring the division between self-expression and commercial work that the pictorialists had been at such pains to erect around the turn of the century. Artists such as Cecil Beaton, Man Ray, Moholy-Nagy and Paul Outerbridge graced the early days of advertising with their work. Borrowing the glittery glow of cinema, fashion and celebrity photography flourished through the lenses of Baron Adolph de Meyer, Horst P. Horst, Edward Steichen and Martin Munkacsi. Advertisers were willing to be influenced by what artists had to say about design, type and composition, even allowing Surrealism to enter the structure of commercial publications. Some of these early influences remain unchanged to this day.

This successful liaison between art and commerce marks perhaps the apotheosis of set-up photography. But as the world of commercial photography grew in complexity it required more specialization on the part of its players. Artists could no

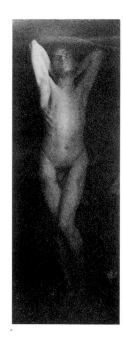

Figure 4: F. Holland Day, <u>Study for the Crucifixion</u>, ca.1898. Platinum print. Courtesy The Metropolitan Museum of Art, The Alfred Stieglitz Collection, 1949.

1. Naomi Rosenblum, <u>A World History of Photography</u>, New York: Abbeville Press, 1984.

2. <u>Ibid</u>.

longer control the entire process: art directors, stylists, photo editors and over-demanding clients reduced the job of the photographer to that of an uncreative technician. The love story between fine and commercial photography came abruptly to an end.

Meanwhile, government programs such as the Farm Security Administration and photo-based weeklies such as Life, Look, Paris Match, and Picture Post, offered documentary photographers a wide array of employment possibilities. In America, the Depression was combated with inspiring photographic images, many depicting the nobility (as well as suffering) of working-class Americans. Lewis Hine, Walker Evans and Berenice Abbott wrote extensively on the importance of truth in photography, and its social implications. Nevertheless, photographers were not opposed to "enhancing" composition and treatment of light in their "documentary" photographs. Margaret Bourke-White, for example, rearranged a line of flood victims standing under a billboard (At the Time of the Louisville Flood, 1937) which exalted "the American way," to create a more "aesthetic" image.

In the climate of conformity and economic complacency of the 1950's photographers turned from the social and political, and focused instead on more intimate and personal interpretations of the world. And to some extent, just as the invention of photography freed painters from documenting reality, so the new medium of television, with its ability to present images "live," seemed more immediately "real" and so prompted photography to develop in other directions. Inspired by abstract art, many photographers sought to expose pure form, while photo-journals such as Life began to feature aerial, microscopic and astronomic photography.

During the 1960s and early 1970s artistic photography was predominantly documentary in nature; nevertheless, many photographers did begin to question the photograph's documentary validity. This trend continued in the work of numerous artists in the 1980s, who often borrowed, and subverted, the manipulative strategies of the mass media.

With the introduction of digital photography in the 1990s, renewed interest in the mechanics of representation has developed. As a result there has been a resurrection of a low-tech, labor-intensive approach to depicting objects and images. Many photographers have abandoned sophisticated equipment to experiment with alternative cameras, many homemade. Others have downsized the apparatus of media fabrication to the intimacy of their studios by making toy scenarios, theatrical allegories, and "portraits" of handmade subjects.

The computer bit has leveled the hierarchical relationship of reality over representation, giving the image an unconditional autonomy. This autonomy is the ultimate achievement as well as the ultimate failure of the digital image. The more the digital facsimile astonishes us with its capacity to transform, the more it erodes our faith in all images. The photographers in this exhibition acknowledge this state of affairs, and through telling details enlist the viewer in the discovery and exposure of the mechanics of their illusions.

The Bad Actor

Once during a third-rate performance of Othello, I had the chance to experience the beneficial shortcomings of perfectionism in representation. Joey Grimaldi, the actor responsible for incarnating the Moorish celebrity, conveyed, with his heavy Brooklyn accent, hopeless stuttering and transparent amateurism, the image of a jester with his face painted black. During the entire play I observed no break in Joey's embarrassing inability to persuade the public of the metamorphosis of his identity. As a result of this mediocre performance, the character alternated between Joey, (married, two kids, a plumber from Astoria who took theater lessons on weekends), and the jealous Moorish general in constant search of bad advice. The reality that leaked from the character of Othello made it possible for the whole dynamics of theater to become transparent and comprehensible. This frenetic negotiation, even though unable to bring to mind either the character of Othello, or that of Joey, illustrated with great clarity the essence of representation.

The difference between a chemical and a digital photograph is like the difference between a shadow and a ghost: While digital images (like ghosts) have lost their bond with the material world they continue to borrow its forms, whereas chemical photographs (like shadows) must rely on the material world to achieve their form. For the artists in Making It Real, the importance of "doing it chemically" comes from their innermost desire to preserve a link between fact and fiction. Yet just as the photo-chemical bond between reality and image will always exist, so too will the invisible differences that separate the chemical from the digital image continue to exist as hidden lies. As Lewis Hine once remarked, "While photographs may not lie, liars may photograph."

Set-up photography has consistently evolved synchronically with commercial demands for an idealized subject, and for this reason it reveals a great deal more about the photographer's intentions than it does about the subject portrayed. As we start to unveil the patterns in the relatively short history of photography, we may be able to look at pictures with the same concern for their artifice and formal rhetoric that, for example, we bring to the appreciation of theater.

By choosing to play with the permeable borders between fiction and illusion, the artists in this exhibition convey a concern with our decaying belief in reality as something that can be impartially defined and objectively recorded by a neutral witness. In practice, fictional fiction is perhaps as close as we can get to reality. As theater director Constantin Stanislavsky once pointed out, the hardest role an actor will ever play is that of an actor, especially a bad one, for there is nothing within an actor's memory that he can use to portray such a character. He will have to depend entirely on his imagination; he will have to act twice as much in order to make it real.[3]

The point I wish to make is not that we have lost a grasp on "reality" we once maintained, but that the emergence of digital imaging is opening up new ways of thinking about the photographic image. As Fred Ritchin writes: "We have before us a chance to explore a new beginning, or at least an exhilarating turn. One hopes that the discussion will not simply blame or applaud the technology for all that is and will be happening to photographic imagery. The discussion should question the nature of photography and its potential role in our evolving society."[4]

3. Constantin Stanislavsky, An Actor Prepares, translated by Elizabeth Reynolds Hapgood, Theater Arts Press, 1948.

4. Fred Ritchin, In Our Own Image: The Coming Revolution in Photography; How Computer Technology is Changing Our View of the World, New York: Aperture, 1990.

What's Wrong with This Picture?

When I worked for an advertising agency in 1979, my boss, a certain Mr. Souza, spent most of his time terrorizing us young trainees with a litany of techniques on how to make things look "more real." He would always allow certain imperfections to remain in the last draft of photo ads: a speck of dust, a scratch on the product's package, some lint in the model's sweater—"touches of truth," as he described them. However, our "touches of truth" never seemed to be the same as his. When we confronted him, he explained that the essence of hyperreality wasn't simply about making mistakes, it was about being able to communicate them. Anything believable that happens in media, he said, does so because it carries a feeling that it should not have happened in the first place; that goes for selling deodorant or for reporting a plane crash.

I never forgot those words. I left the agency shortly after Mr. Souza got fired for sloppy work and decided to become a sports writer.

Plates

Tina Barney

I've become more frustrated and dissatisfied. I realize that I simply can't expect people to let go of themselves completely and expose their emotions—no matter how much they wish to cooperate and collaborate with me.

I always knew that, somehow, actors would be the answer to my dream of a totally unself-conscious and uninhibited human being. Or at least what appears to be that. What interests me in these pictures is that Sheena and Roy are my friends. They are a couple. And they are actors. How do they know, and therefore, how could I possibly know which expressions and movements are from their own lives or from their acting lives? Like Hume Cronin and Jessica Tandy, Katherine Hepburn and Spencer Tracy, George Burns and Gracie Allen—How did any of these couples know what is (was) an act and what is (was) real life?

Courtesy Blind Spot Inc. Published in Blind Spot, Issue 5, New York, 1995

Sheena and Roy, 1994.
Chromogenic color print, 48 x 60 inches

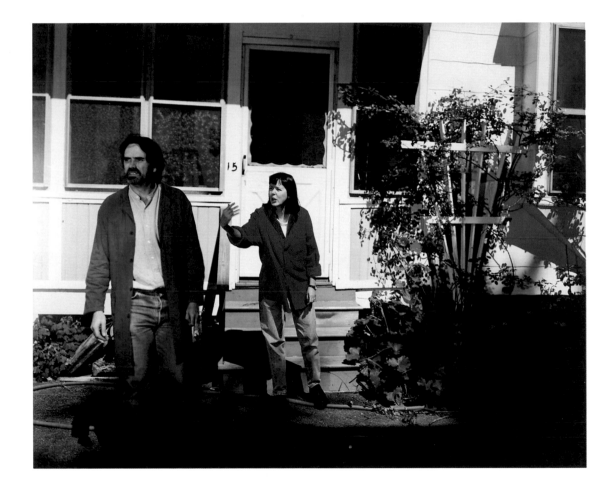

Zeke Berman

While in art school I became interested in perception theory. My sculpture didn't provide an outlet for this interest until the idea of working in the studio with a camera occurred to me. The camera became a kind of intermediary in the sculptural process and would dictate what I was making. I would point it at the floor and only build within the area defined by the viewfinder. Without being consciously aware of it, I moved away from the construction of objects to the construction of images: away from the sculptural to the pictorial.

The optical nature of the camera offered a natural outlet for my interest in perception theory and allowed me to create spatial illusions that were a play between three-dimensions and two-dimensions. I had read Arnheim's Art and Visual Perception, and was particularly interested in the notion that visual experience is provisional to the cognitive operations that we perform—mediated by our minds.

Seeing is thinking, provisional rather than restricted. My early works are about these illusions. They seem to infer so much about the nature of photographic reality—by challenging it, by contradicting normal optical descriptions. There is something humorous in the imperfection of the illusion. The viewer has to think—to become almost viscerally aware of the provisional nature of perception. These pictures are the exceptions that prove the rule. If a picture can be evidence of a larger body of phenomena, then it is effective and very powerful. This is what I hope to achieve. Like lifting a rock and peeking at what is underneath.

Cubes, 1979.
Gelatin silver print, 16 x 20 inches

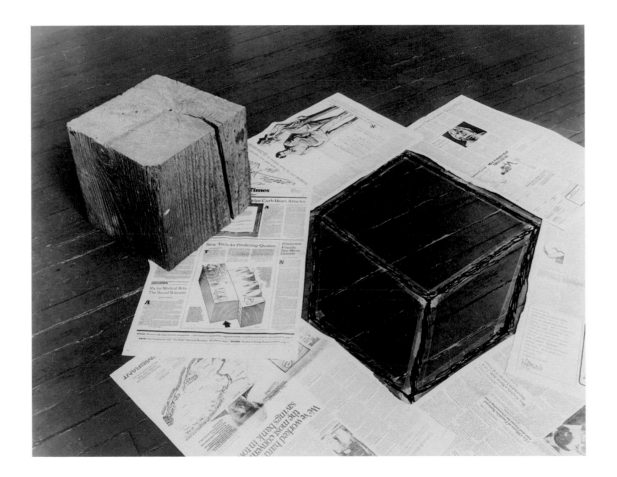

James Casebere

Casebere upsets the conventional myth of the photograph as seamless, objective truth. His images are intentionally artful; they lack the details of either nature or culture. The cold, hard metal of the gun barrel reads the same as the slimy, insipid plastic of the kitchen appliance. Grass looks like linoleum. And massive prison walls come across as nothing more than flimsy panels put together with cardboard and glue. There are no captions or extended titles. Casebere reduces the world to the "effect of the real," the simulcra of a broad range of cultural and social genres—from family life (Utility Room 1982; The Kitchen 1982; Dining Room with Corral, 1988), education (Library, 1979), and law (Courtroom, 1979; Prison Cell with Toilet, 1993), to commerce (Storefront, 1982/87), leisure (Back Porch, 1982; Beachfront, 1990), and religion (Pulpit, 1985).

Excerpt from "Social Studies" by Maurice Berger, 1996, in Model Cultures: James Casebere, Photographs 1975-1996, San Francisco: The Friends of Photography, 1996

Prison Cell with Toilet, 1993.
Gelatin silver print, 29 $\frac{1}{2}$ x 39 $\frac{1}{2}$ inches

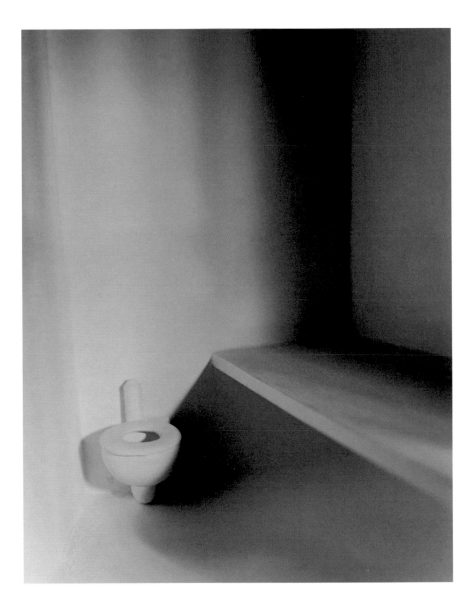

Catherine Chalmers

My interest in doing the Formaldehyde series was to investigate the experience of looking at nature. Is the occasion diminished or enhanced if the subject is not the real thing in its native environment?

Our culture surrounds itself with natural forms: Flora and fauna are on our walls, beds, and clothes. Animals abound on TV and in print, yet we are relatively removed from them in the flesh.

We persevere in our need for nature even though we rarely get the real thing. Is it that we prefer the substitute? Most of us would rather see a photograph of a spider than meet a moving one. And usually when one is encountered it's quickly killed.

My "nature" photographs of animals raised in a laboratory, pickled, shipped to New York City, placed in an alien landscape and captured on film, somehow, in today's climate, seem right at home.

Spotted Salamander, 1992.
From the series, Formaldehyde.
C-print, 60 x 40 inches

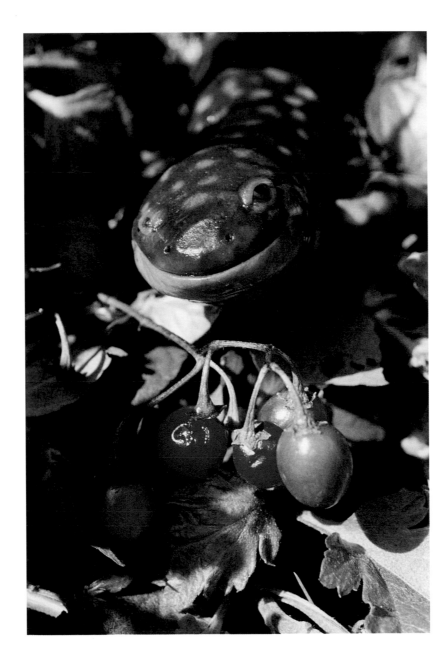

Gregory Crewdson

I employ staging, artifice and theatricality to heighten the fictional content of the photographs and establish them in an imagined world. However, I also try to combine these critical strategies with traditional concerns like pictorial composition, narrative complexity, and photographic beauty. This collision of styles and intentions appears contradictory, but I believe that the photographs produce an effect that hovers between photographic realism and unreality.

The scenes in suburban backyards and gardens explore the domestic landscape and its relationship to the natural world. The highly detailed, large-scale dioramas obsessively recreate the small, dramatic events that occur within this familiar setting. Like the American writer Raymond Carver, I am concerned with the well-rendered detail or gesture and how it can reverberate with larger meaning and significance. In many of my photographs, the dramatic moment revolves around seemingly mundane and unremarkable events. I hope that within the parameters of these imagined landscapes, incidental scenes and occurrences—like a towering dirt pile, a circular formation of robin's eggs, and an excavated hole in the ground—have the mystery and poetic resonance of a ritualistic site or private totem. This clash between the normal and the paranormal produces an uncanny tension that serves to transform the topology of the suburban landscape into a place of both wonder and anxiety.

Untitled, 1994.
C-print, 30 x 40 inches

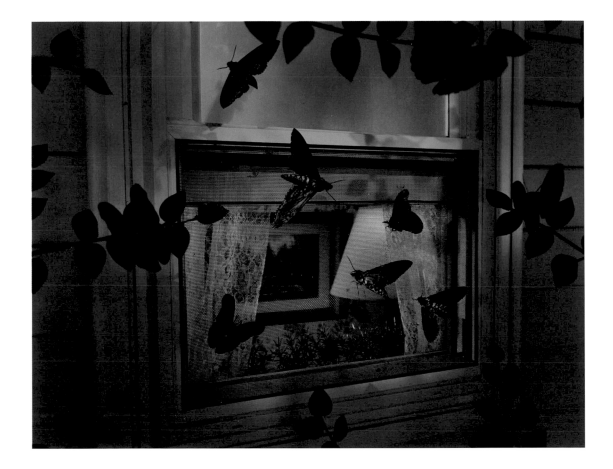

Thomas Demand

Diving Platform, 1994.
C-print, 46$\frac{1}{2}$ x 59 inches

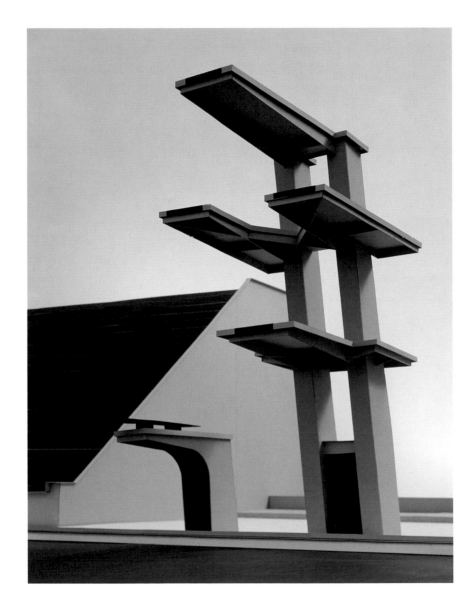

Philip-Lorca diCorcia

Photographs are often the result of being in the right place at the right time and the attributes of photographs people most appreciate often have little to do with things for which the photographer could claim intellectual responsibility. But I believe the result of the photographer's decisions should be visible—photographs should not just be the result of having placed the machine in the right place.

I began to make set-up photographs in 1978, partly because I despised walking around waiting for something to happen. The two works in the exhibition were set up before I even saw the subject. The prostitutes were hired (I pay the same as for sex on the street) after the photograph was arranged, using stand-ins in their place.

I shot the series in Hollywood. People see the gloss I applied—I was working there so it leaked into my work. That snazzy look distances people; they don't believe anything is real unless they see the warts.

These photographs create a certain suspicion. If you look, you know they can't be real, everything has been "corrected;" however, I do not think their fictional aspect makes them any less true. "Truth" is never simply the result of an accumulation of facts.

Joe Reeves, 37, San Fernando, CA, $40, 1990-92.
C-print, 30 x 40 inches

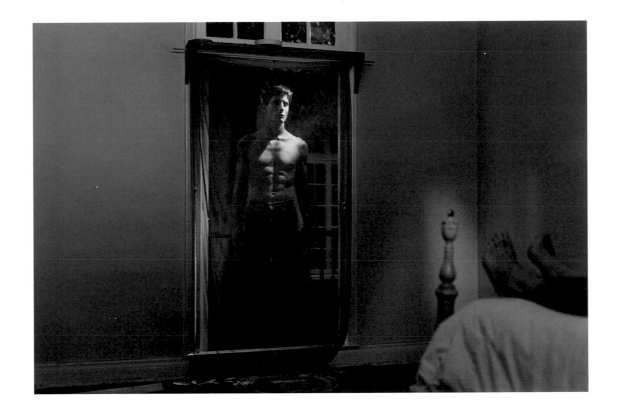

Fischli & Weiss

The Snobs, 1979.
From the series, Wurst.
C-print, $9^1/_2$ x $13^3/_4$ inches

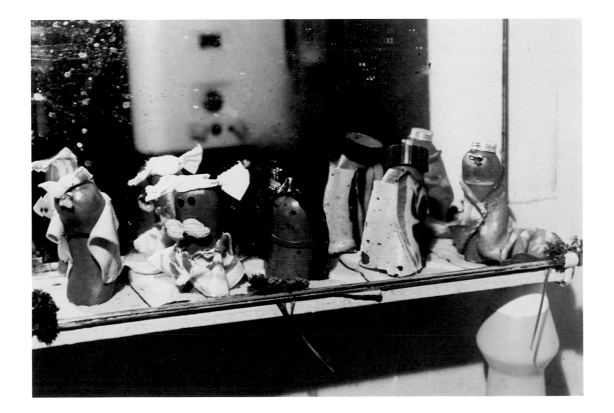

Joan Fontcuberta

Most of my work has dealt with the issue of truth. I want to confront the public with situations that challenge their credibility. In fact, truth is a question of authority and I try to contaminate the mechanisms which articulate this sense of authority. Of course, this strategy of contamination aspires to produce a counter-effect of vaccination.

My projects constitute a parody of the scientific display in different disciplines (ranging from botany, zoology, astronomy, anthropology, art history, etc.). I enjoy ironically criticizing science for its arrogant assumption that only through its disciplines is the truth found.

Historically, photography has been a technology that supplies visual evidence and it is mainly for this reason I use this medium.

Cala Rasca, 1983.
From the series, Herbarium.
Gelatin silver print, 10½ x 8½ inches

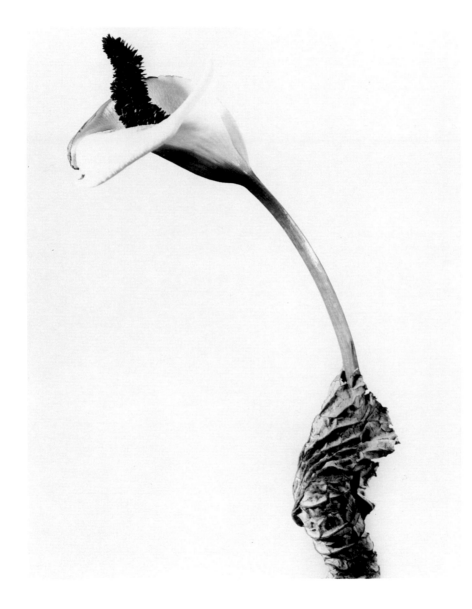

Peter Garfield

The Mobile Home series uses airborne houses in various states of destruction as a signifier for psychic trauma. Influenced partly by media images of natural disasters, I am interested in transforming these houses into somewhat humorous icons of the volatile psychological and emotional elements contained behind the typical American suburban facades of decorum and well-being.

These images are from single, unmanipulated 35mm negatives shot of model houses that I build. I enhance the mundane, "snapshot" quality (with grainy film and by creating a blur effect) to further confound the viewer's sense of what is reality and what is fantasy.

Mobile Home (Split Level), 1995.
C-print, 40 x 30 inches

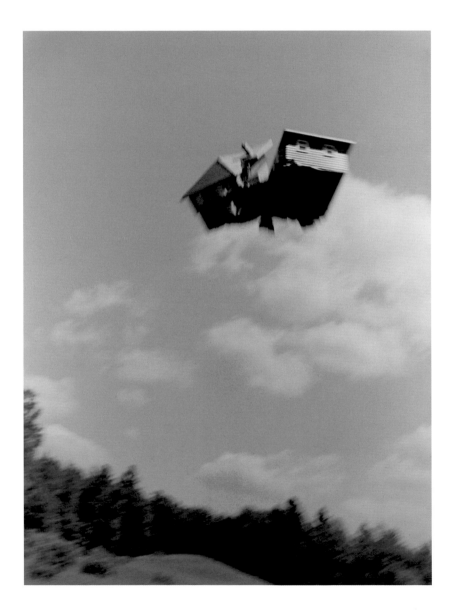

Charles Griffin

These <u>Ash</u> photographs are about the resculpting of the spirit and energy of a loved-one who had "passed away." They describe the attempt to "make it real," in the hope of resurrecting a new relationship.

<u>Ash V</u>, 1995.
Gelatin silver print, 60 x 48 inches

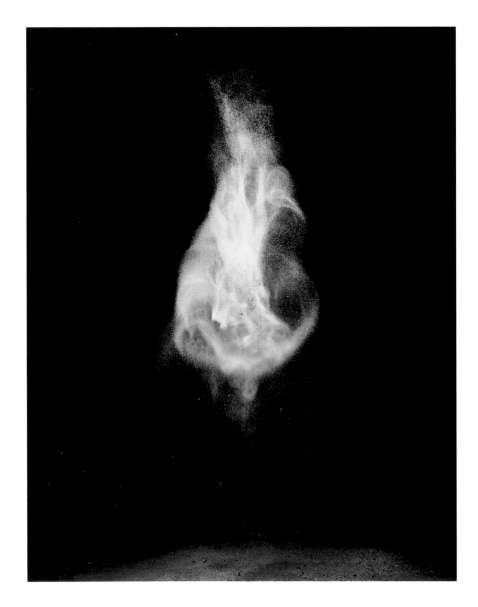

Jan Henle

The La Jíbarita project was begun in December of 1991, on an abandoned coffee plantation in the southwestern mountains of Puerto Rico. For eight months, four jíbaros (Puerto Rican mountain men) and I worked with machetes, axes, a bulldozer, and hoes on a large-scale land sculpture. The perimeter of the carving in the bush measured 100 x 200 x 155 x 135 x 225 feet—an attempt at no thing—ethereal and blood-calm, burning and empty at the same time.

After the sculpture was transferred to film, the site was planted with coffee again. In 1994, over 3,000 pounds of coffee were harvested. It has no beginning and no end. It was bush, it became earth, it is growing coffee, it is part of life.

La Jíbarita III, 1991–2.
Film drawing/gelatin silver print mounted on
aluminum, 29$\frac{1}{2}$ x 30$\frac{5}{8}$ inches
Maquette, 1 of 3

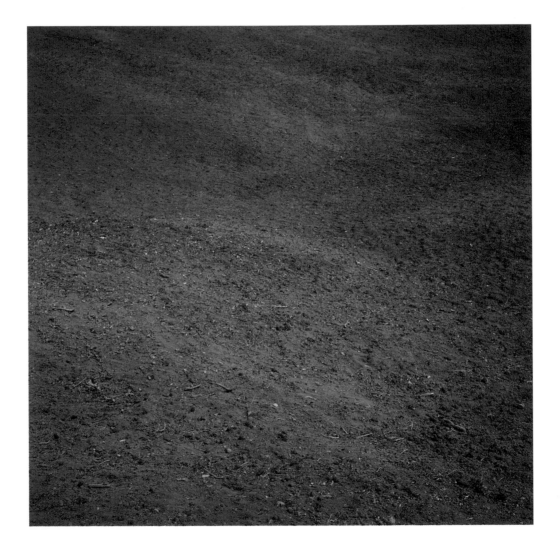

Teun Hocks

Fascinated by the feeling of "wanting to hide from moments not meant to be dangerous," images of someone hiding beneath a fully set tablecloth came to my mind. It was a small step from there to a misplaced and sad picnic.

Whereas many photographers wait for "the moment" and only then take their photographs, I like (as do painters) to determine that moment for myself. I don't want to go in search of the "perfect spot," so I build my own scenes and paint the background. Rather than wait for bad weather, I can make it as sad, lonely and awful as I desire; position myself, play my role, and take a picture in black-and-white. For The Picnic I constructed the human figure covered by the tablecloth and then set the picnic. I was hidden behind the figure; wanting it to look natural I took care that my right hand was visible.

My photographs are taken in black-and-white, but I apply color after blowing up and printing the photographs to emphasize the atmosphere and mold the situation to my will. I am trying to be in control most of the time, to get the work as close as I first saw it in my head.

Untitled (The Picnic), 1990.
Brown-toned silver print with oil paint, 53 x 68 inches

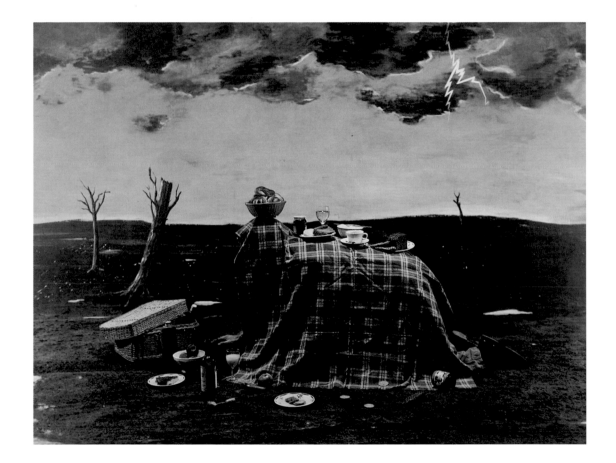

Mike Kelley

These works relate to an earlier body of work about the conventions of picturing the formless, a set of drawings called the Garbage Drawings (1988), that were illustrations of depictions of garbage dumps lifted from comic books. In Untitled (11) (1994), I took this trope of picturing the unpicturable, and applied it to photography. I wanted to photograph something that seemed to be formless, but at the same time looked like something, so the viewer wouldn't know exactly what they were or where they were. I made them look as if they were floating—unscientific—like mental images.

On another level these images relate to biomorphic abstractions of the 1940s, and similarly address the tension between pictorial conventions and spatial conventions, while still playing with formlessness.

Untitled (11), 1994.
Gelatin silver print, 31 x 22¹/₂ inches

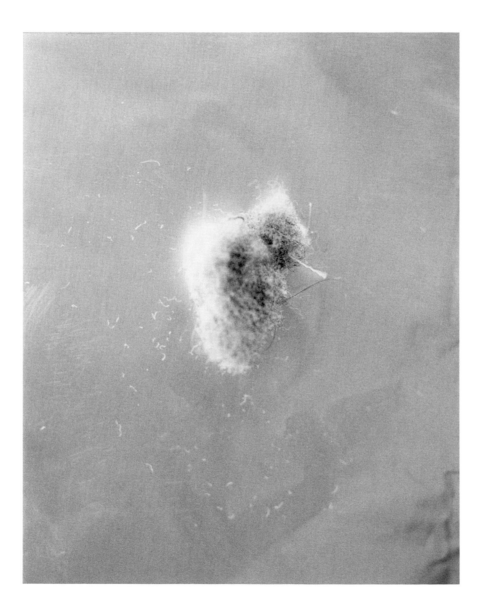

Wilmar Koenig

Untitled (Caveman), 1993.
Unique chromogenic print, 41 x 36 inches

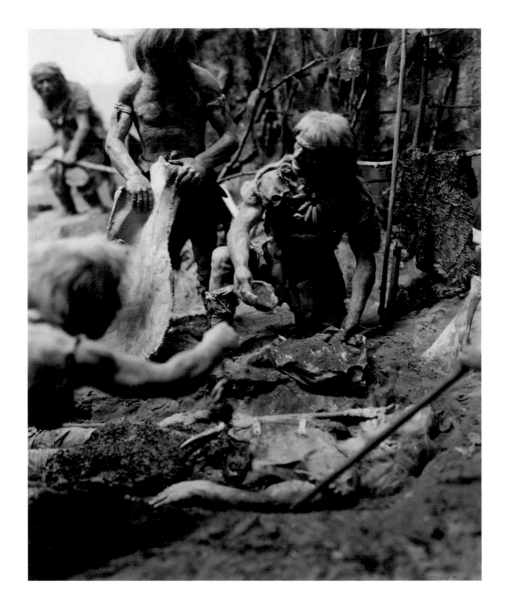

David Levinthal

With a photograph, one can produce within a single image both the presence of reality and the illusion of fantasy. The apparent verisimilitude of the photographic image, once its hallmark, is now simply another artistic tool—a means to lead the viewer into worlds of heretofore consciously unimagined (but unconsciously extant) imagery. What stronger signifier of this conscious/unconscious world could there be but toys?

I have always found toys to be far more than benign objects. They are the metaphors for the culture from which they come; the seemingly innocent tools of socialization: one of the more potent means of presenting the accepted modes and roles of behavior to future generations.

Toys bring us back to our memories, yet simultaneously thrust us forward into our private reveries. Thus nothing would seem a more perfect instrument with which to probe the depths of the subconscious than to merge the iconography depicted by the amorphous plastic figures with the apparent reality brought to an image by means of the photographic process.

Untitled, 1988.
From the series, The Wild West.
Polaroid Polacolor print, 24 x 20 inches

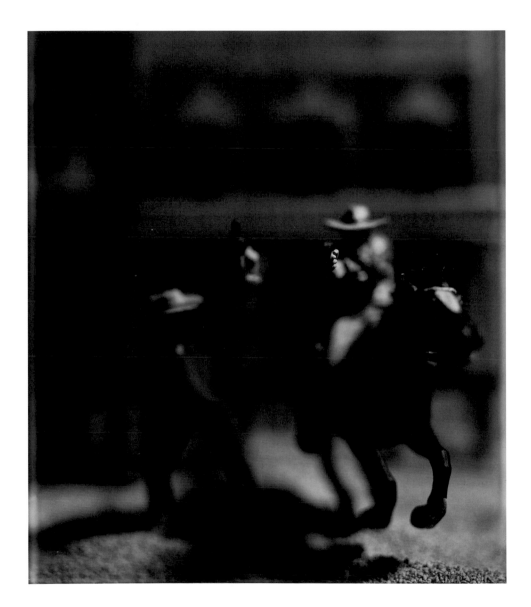

Martí Llorens

For most people the memory of the Spanish Civil War in 1936 consists of a series of black-and-white images showing armed militiamen raising clenched fists and waving a flag on their way to the front in a rickety truck replete with cushions.

Some of these images have become famous: Robert Capa's mortally wounded militiamen, the street battles of Hans Namuth and Georg Reisner, the Barcelona barricades of Augustí Centelles.

1995. A hot July in Barcelona. I am walking along the Ramblas when a large group of armed militiamen suddenly appear. They are waving a red-and-black flag and happily raising their fists to greet people like me, who are gaping at them in surprise. Behind them comes an old Ford V8 truck replete with striped cushions.

I return home, find some black-and-white film, and two old fixed-optic cameras: a basic UNIVEX with only two functions, "snapshot" and "pose," and a 1930s Agfa folding-roll film camera.

The militiamen are still there, singing the anarchist anthem, "A Las Barricadas." It turns out to be a rehearsal for the film Libertarias.

I mingle with them, when suddenly I have the sensation that I am looking at the militiamen from the photos of Capa, Namuth, and Centelles walking to and fro, smoking and eating sandwiches. It's all rather surreal.

I speak to some of them. They laugh and raise their fists. From a truck full of cushions they call to me. They ask me why I am photographing them with such antiquated cameras.

"Because you really deserve it," I think to myself.

© Martí Llorens, 1996

Portrait of Militiaman Antonio on a Truck, 1996.
From the series, Revolutionary Memoirs, 1996.
Toned gelatin silver print, 4$^1/_8$ x 2$^1/_2$ inches

Translation of text on reverse of photograph:

(Bujaraloz, September 25, 1936)
I write from the truck that brought us to Barcelona.
We've done two stops on the way. When I arrive,
I will write to you longer. I've got everything: I eat,
sleep. I trust that we will all be better soon. Please
ask Mercedes not to worry because I have not written
to her. I haven't been able to do it so far. This portrait
was done for me by an English photographer when
leaving Barcelona.

A hug, Antonio

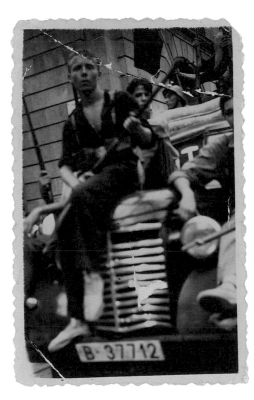

Estic bé; no se encare aont aniré; escric desde dalt del camió que va durnos de Barcelona hem fet dos parades, puro abans quan estigui a lloc ja escriuré mes llargament. Tinc de tot, menjar, dormir i tenim la confiança que encara estarem millor. La Mercé que no estranyi si no l'escric peró es que no puc. Aquest retrat me l·ha fet un inglés quan sortrem de Barcelona

A reveure Antonio

Paul McCarthy

The masks were worn during my performances in the 1970s and early 1980s. After the performances, the masks were stored in trunks and suitcases along with props from the performances. The trunks and suitcases were exhibited on several occasions, always closed. During these exhibitions, the contents were not revealed. I opened the trunks and suitcases in 1992 and photographed each object separately. There are seven masks.

Mask (Pig), 1994.
Laminated Cibachrome print, 20 x 16 inches

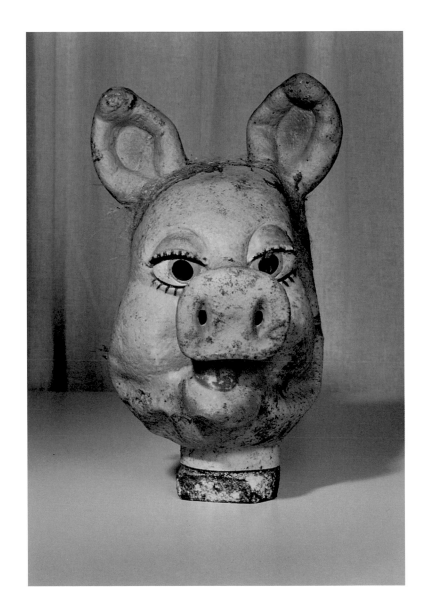

Brian McCarty

As a child in modern America, I had of course come to know the camera very well. It had recorded every birthday, Christmas, or "special" moment in my life, and frozen it forever in time. My interest in these photographs didn't lie in trying to hold onto an event in my life: I wanted to escape from my own reality and create a new one in front of the camera, immerse myself in it as I looked through the view-finder. This became my method. I would make elaborate scenes of imaginary places and events and then look for hours at what I had created; the actual pictures were more of an afterthought. As more and more of my little worlds were born, photographed, and destroyed I realized that the photographs I made reflected my feelings about the world around me more clearly than I could ever articulate with any other means.

Untitled, 1995.
From the series, Suburbia.
C-print, 11 x 14 inches

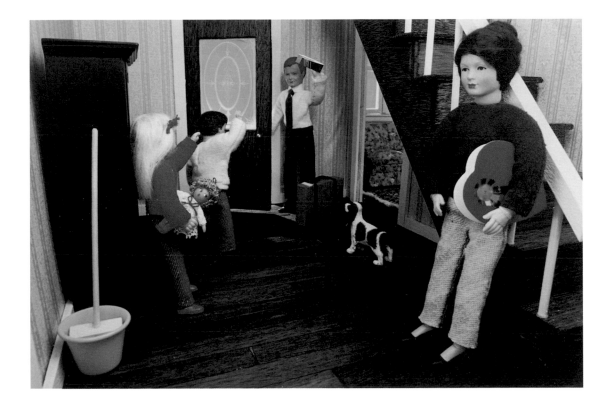

Abelardo Morell

These pictures have to do with my love and curiosity for the mysteries and beauty of photography itself.

Light Bulb, 1991.
Gelatin silver print, 20 x 24 inches

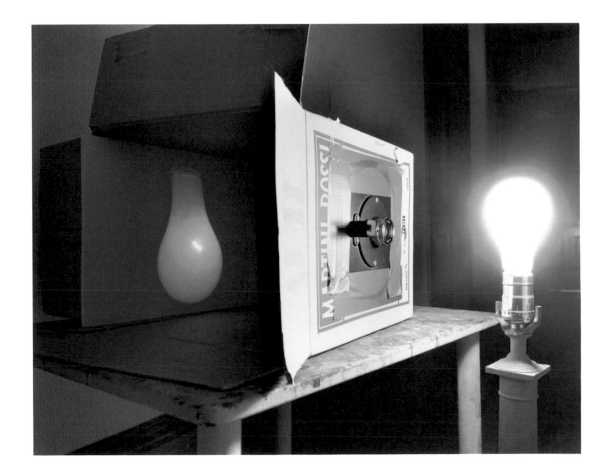

Warren Neidich

Eloise at the Plaza is an example of a children's game in which the player learns to uncover hidden visual clues. In "Visual Games: Recoding American History," this trope is used to make an overall fictive construction in which the set-up genre, in the context of an historical scenario, plays an essential role.

Each image contains an anachronism that was either found at the site, as in the case of the airplane, or placed at the scene prior to taking the picture, as was the "No Smoking" sign. As the viewer looks at the image it becomes obvious that something is "wrong." The numerous pictorial discrepancies within the pseudo-nineteenth century scenes and the telling posture/style of the contemporary characters/actors who inhabit them are metonymical designations for "uncovered" historical fictions which dissolve as the viewer becomes mesmerized by the game.

Just Like TV, 1985.
From the series, Part 1, American History.
Albumen print, 6 x 8 inches

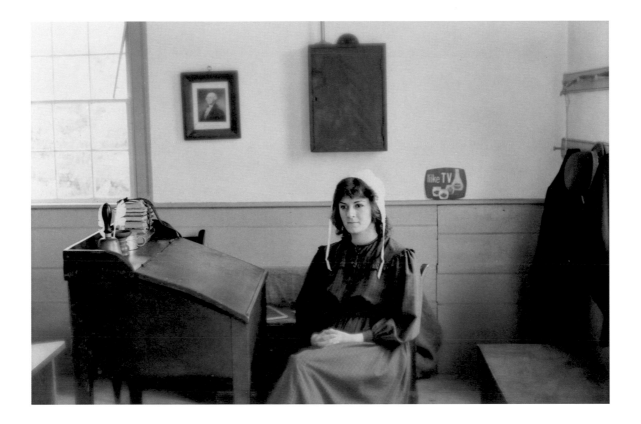

Jorge Ribalta

If the function of the model is to provide raw material for the imagination, then its ideal, utopian function is to "come to life." This notion is expressed in the myth of Pygmalion, which explores the magic (and fetishistic) side of imitation. This magical aspect has a two-fold dimension: the purely technical, (the strange and wonderful re-occurrence of the object by way of its imitation); and the existence of the object itself which its imitation affirms. In this latter dimension, imitation simultaneously deceives while it tells the truth about its deceptions: it is proof of the existence of something that doesn't exist. (Imitation is here, paradoxically, a proof of the independence of imagination). Through this magical resonance the image preserves its disturbing and troubling potential, its distance, and its deep strangeness.

Untitled #60, 1989.
Gelatin silver print, 19 $^7/_8$ x 23 $^7/_8$ inches

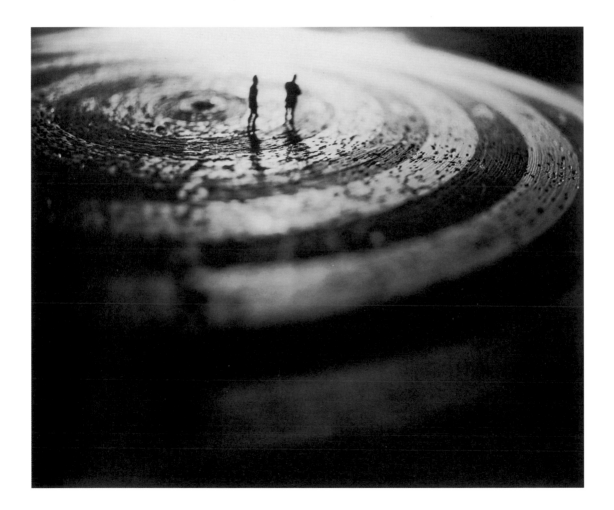

Collier Schorr

Das Schloss (Horsti), 1994.
C-print mounted on Plexiglas, 70 x 49$\frac{1}{4}$ inches

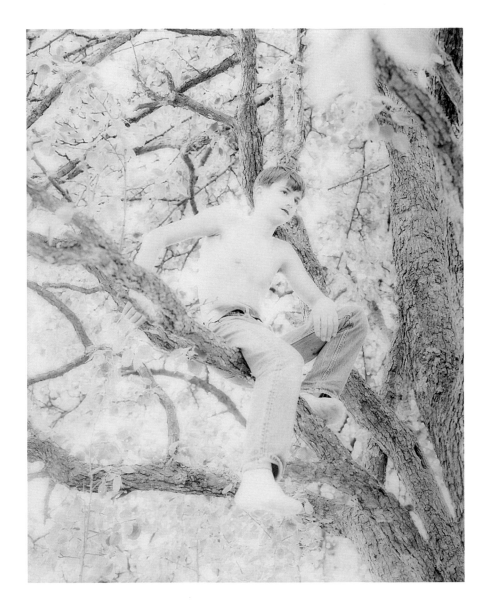

Cindy Sherman

Untitled, 1981.
C-print, 24 x 48 inches

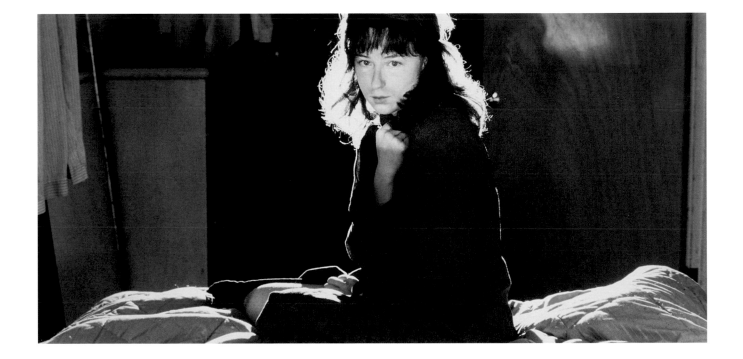

Kenneth Shorr

The final revelation is that lying, the telling of beautiful untrue things is the proper aim of art.

Oscar Wilde

Bio Fear, 1995.
Gelatin silver print, 10 x 8 inches

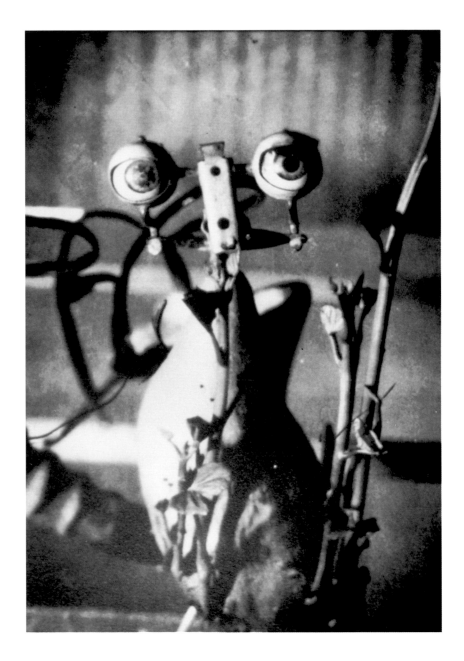

Laurie Simmons

Linda Yablonsky: Your pictures are re-creations of real-life scenes on which you've superimposed another reality. They're sort of super-natural.

Laurie Simmons: I go for the realism. . . . I don't want to make supernatural pictures. Characters never fly. I'm not interested in a visual Magical Realism. Given a chance, I always go for accurate perspective and scale in the hopes that someone might believe the scene.

LY: So you're a kind of trickster.

LS: I don't mind being that.

LY: You can control the situation with dolls, but then you're limited by the fact that they have so few physical expressions.

LS: That was a plus. There's always a mood you project on a human face. In a sense, the face of a doll is far more open. It's not possible for a human to sit in a serious state of repose. People are either sad or happy or pensive or simply inscrutable, whereas a doll has one expression you don't question, it's the doll's face.

LY: Why are these pictures called The Music of Regret? Everyone's smiling. They seem fairly happy.

The Music of Regret II, 1994.

Black and white photograph, 60 x 40 inches

LS: Melancholy seems to me to be a complex and elevated emotion, far above sadness and happiness. It's also theatrical, which is what I love about it. A less favorite emotion, if you can rate emotions one–to–ten, is jealousy. It's awful. But regret—for me that's the killer. There are emotions psychologists call the "sadness grouping" which includes melancholia, disappointment and discouragement. Regret fits here too. But regret is about lost opportunity, moments, or a lost life, and often regret focuses on things outside of our control. When you regret something, the tendency is to go over the facts again and again, and then to imagine changing your actions and then following the chain of events that would have occurred. So in a sense you're imagining rewriting the past.

LY: So you regret something?

LS: Well yes, doesn't everybody spend some time wondering, "what if?"

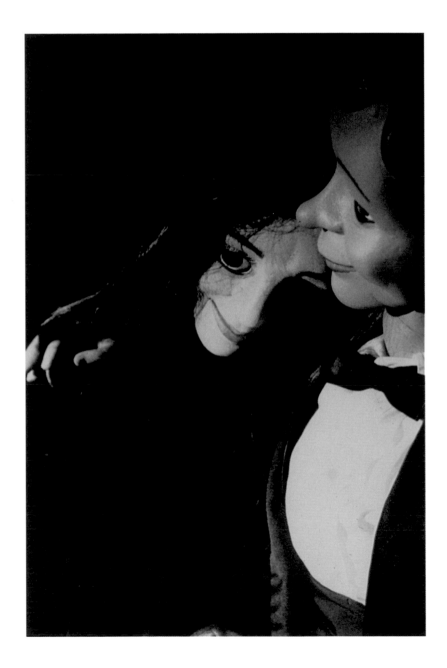

Sandy Skoglund

The only reality we can be sure of is death.

Spirituality in the Flesh, 1992.
Cibachrome print, 36 x 28 inches

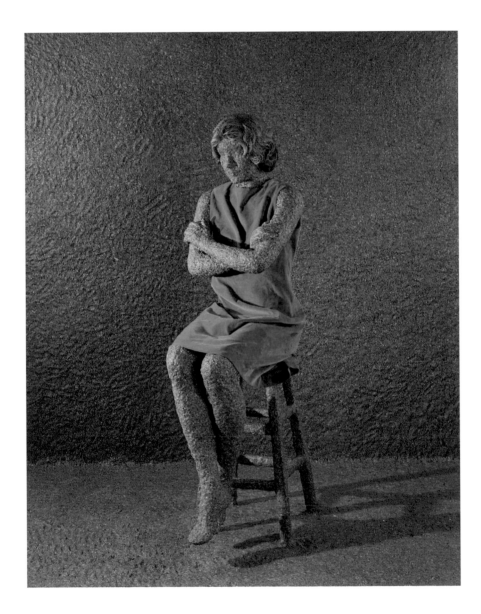

Hiroshi Sugimoto

Queen Victoria, 1994.
Gelatin silver print, 20 x 24 inches

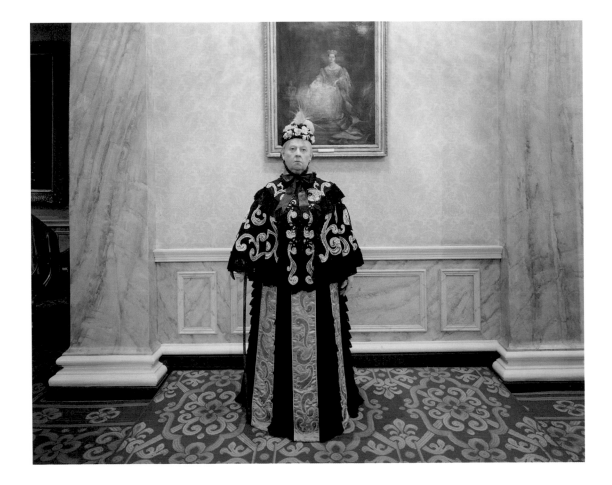

Bernard Voïta

When one trusts photography blindly, it is literally because one doesn't see it.

The architectural views that I propose are in fact fragmentary constructions of familiar objects spread out in the studio in a specific order dictated by light. They exist and find their place only by the reflection that emanates from the surface of the photographic emulsion.

By taking photography inside out, I catch it in its own trap. It is a self-representation of photography, which in fact dissolves its power.

Translated by Glenn McMillan

Untitled, 1995.
Gelatin silver print, 9 x 9½ inches

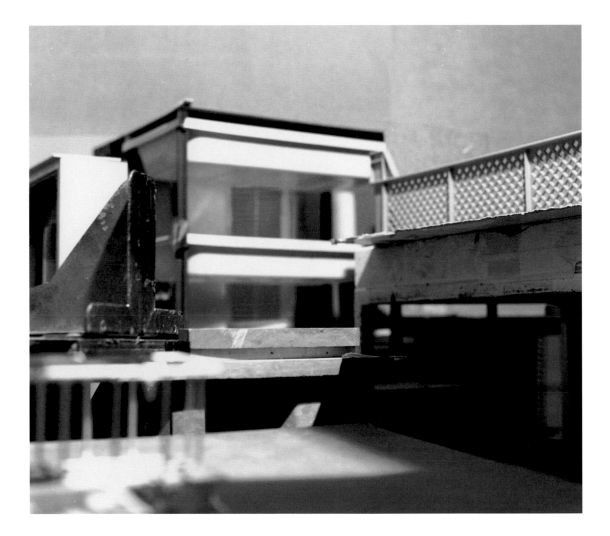

Boyd Webb

These images are concerned with society's most central enthusiasms: food and sex. Each image was lit internally so light and color could emanate from the subject in the manner of a luminous x-ray.

In the orange image, dozens of egg yolks—large, small, free-range, and otherwise—lie, pizza-like, awaiting the attention of the object in the left-hand panel.

The spiral form, cut from cast catering gelatin, alludes to the IUD contraceptive, the tangle spermatozoa might get into when presented with such choice, and the sliver of lemon zest that comes with espresso, if you are lucky.

Left: Petri, 1994.
Right: In Vitro, 1994.
Diptych: Cibachrome prints, 30 x 60 inches each

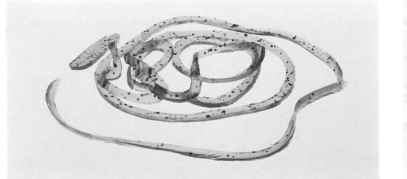 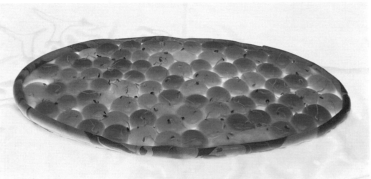

Checklist of the Exhibition

Height precedes width.

Tina Barney
Born: 1945, New York, New York
Resides: New York, New York

Sheena and Roy, 1994
Chromogenic color print
48 x 60 inches
Courtesy Janet Borden Inc., New York

Zeke Berman
Born: 1951, New York, New York
Resides: New York, New York

Still Life with Necker Cube, 1979
Gelatin silver print
16 x 20 inches
Courtesy Laurence Miller Gallery, New York

Cubes, 1979
Gelatin silver print
16 x 20 inches
Courtesy Laurence Miller Gallery, New York

James Casebere
Born: 1953, Lansing, Michigan
Resides: New York, New York

House on the Hill, 1990
Gelatin silver print
30 x 40 inches
Courtesy the artist

Prison Cell with Toilet, 1993
Gelatin silver print
29 $\frac{1}{2}$ x 39 $\frac{1}{2}$ inches
Courtesy the artist

Catherine Chalmers
Born: 1957, San Mateo, California
Resides: New York, New York

Bumble Bee, 1992
From the series, Formaldehyde
C-print
60 x 40 inches
Courtesy the artist

Spotted Salamander, 1992
From the series, Formaldehyde
C-print
60 x 40 inches
Courtesy the artist

Gregory Crewdson
Born: 1962, Brooklyn, New York
Resides: New York, New York

Untitled, 1994
C-print
30 x 40 inches
Courtesy Luhring Augustine, New York

Untitled, 1994
C-print
30 x 40 inches
Courtesy Luhring Augustine, New York

Thomas Demand
Born: 1964, Munich, Germany
Resides: Berlin, Germany

Diving Platform, 1994
C-print
46 1/2 x 59 inches
Courtesy the artist and Max Protetch Gallery,
New York

Staircase, 1995
C-print
46 $\frac{1}{2}$ x 59 inches
Courtesy the artist, Max Protetch Gallery, New
York and the Albright-Knox Art Gallery, Buffalo,
New York. Elisabeth H. Gates Fund, 1996.

Philip-Lorca diCorcia
Born: 1953, Hartford, Connecticut
Resides: New York, New York

Joe Reeves, 37, San Fernando, CA, $40, 1990-92
C-print
30 x 40 inches
Courtesy the artist and
PaceWildensteinMacGill, New York

William Charles Everlove, 26, Stockholm via Arizona, $40, 1990-92
C-print
30 X 40 inches
Courtesy the artist and PaceWildensteinMacGill, New York

Fischli & Weiss

Peter Fischli
Born: 1952, Zurich, Switzerland
Resides: Zurich, Switzerland

David Weiss
Born: 1946, Zurich, Switzerland
Resides: Zurich, Switzerland

The Auto Accident, 1979
From the series, Wurst
C-print
9 $\frac{1}{4}$ x 13 $\frac{1}{2}$ inches
Courtesy Wooster Gardens/Brent Sikkema, New York

The Snobs, 1979
From the series, Wurst
C-print
9 $\frac{1}{4}$ x 13 $\frac{1}{2}$ inches
Courtesy Wooster Gardens/Brent Sikkema, New York

Joan Fontcuberta
Born: 1955, Barcelona, Spain
Resides: Barcelona, Spain

Cala Rasca, 1983
From the series, Herbarium
Gelatin silver print
10 $\frac{1}{2}$ x 8 $\frac{1}{2}$ inches
Collection Tom Gitterman. Courtesy Zabriskie Gallery, New York

Lavandula Angustifolia, 1984
From the series, Herbarium
Gelatin silver print
16 x 12 inches
Courtesy Zabriskie Gallery, New York

Peter Garfield
Born: 1961, Stamford, Connecticut
Resides: Brooklyn, New York

Mobile Home (Dusk), 1995
C-print
40 x 30 inches
Courtesy the artist

Mobile Home (Split Level), 1995
C-print
40 x 30 inches
Courtesy the artist

Charles Griffin
Born: 1955, New York, New York
Resides: New York, New York

Ash IV, 1995
Gelatin silver print
60 x 48 inches
Courtesy the artist

Ash V, 1995
Gelatin silver print
60 x 48 inches
Courtesy the artist

Jan Henle
Born: 1948, New York, New York
Resides: New York, New York

La Jíbarita III, 1991-92
Film drawing/gelatin silver print mounted on aluminum
29 $\frac{1}{2}$ x 30 $\frac{5}{8}$ inches
Maquette, 1 of 3
Courtesy Wooster Gardens/Brent Sikkema, New York

La Jíbarita X, 1991-92
Film drawing/gelatin silver print mounted on aluminum
18 $\frac{1}{2}$ x 19 $\frac{5}{8}$ inches
Maquette
Courtesy Wooster Gardens/Brent Sikkema, New York

Teun Hocks
Born: 1947, Leidin, Holland
Resides: Breda, Holland

Untitled (The Picnic), 1990
Brown-toned silver print with oil paint
53 x 68 inches
Collection The Progressive Corporation, Cleveland, Ohio

Mike Kelley
Born: 1954, Detroit, Michigan
Resides: Los Angeles, California

Untitled (11), 1994
Gelatin silver print
31 x 22 $\frac{1}{2}$ inches
Collection Tom Peters

Wilmar Koenig
Born: 1952, Berlin, Germany
Resides: Berlin, Germany

Untitled (Caveman), 1993
Unique chromogenic print
41 x 36 inches
Courtesy Janet Borden, Inc., New York

David Levinthal
Born: 1949, San Francisco, California
Resides: New York, New York

Hitler Moves East, 1975
Kodalith print
8 x 10 inches
Courtesy Janet Borden, Inc., New York

Untitled, 1988
From the series, The Wild West
Polaroid Polacolor print
24 x 20 inches
Courtesy Janet Borden, Inc., New York

Untitled, 1988
From the series, The Wild West
Polaroid Polacolor print
24 x 20 inches
Courtesy Janet Borden, Inc., New York

Martí Llorens
Born: 1962, Barcelona, Spain
Resides: Barcelona, Spain

From the 16 part series,
Revolutionary Memoirs, 1996
Ten toned gelatin silver prints with handwritten
text on reverse.
Approximately 4 x 2 1/4 inches each
Courtesy Margaret Murray Fine Arts, New York

Paul McCarthy
Born: 1945, Salt Lake City, Utah
Resides: Los Angeles, California

Mask (Rocky), 1994
Laminated Cibachrome print
20 x 16 inches
Collection Alan Power

Mask (Monkey), 1994
Laminated Cibachrome print
20 x 16 inches
Collection Alan Power

Mask (Pig), 1994
Laminated Cibachrome print
20 x 16 inches
Collection Alan Power

Mask (Popeye), 1994
Laminated Cibachrome print
20 x 16 inches
Collection Alan Power

Brian McCarty
Born: 1974, Memphis Tennessee
Resides: New York, New York, and Milan, Italy

Untitled, 1996
From the series, Suburbia
C-print
11 x 14 inches
Courtesy the artist

Untitled, 1996
From the series, Suburbia
C-print
11 x 14 inches
Courtesy the artist

Untitled, 1996
From the series, Suburbia
C-print
11 x 14 inches
Courtesy the artist

Untitled, 1996
From the series, Suburbia
C-print
11 x 14 inches
Courtesy the artist

Abelardo Morell
Born: 1948, Havana, Cuba
Resides: Boston, Massachusetts

Light Bulb, 1991
Gelatin silver print
20 x 24 inches
Courtesy the Bonni Benrubi Gallery, New York

Camera Obscura Image of Manhattan View
Looking West in Empty Room, 1996
Gelatin silver print
20 x 24 inches
Courtesy the Bonni Benrubi Gallery, New York

Warren Neidich
Born: 1961, New York, New York
Resides: New York, New York

Just Like TV, 1985
From the series, Part 1, American History
Albumen print
6 x 8 inches
Courtesy the artist

Rope, 1985
From the series, Part 1, American History
Albumen print
6 x 8 inches
Courtesy the artist

Caterpillar Tractor, 1985
From the series, Part 1, American History
Albumen print
6 x 8 inches
Courtesy the artist

No Smoking, 1985
From the series, Part 1, American History
Albumen print
6 x 8 inches
Courtesy the artist

Jorge Ribalta
Born: 1963, Barcelona, Spain
Resides: Barcelona, Spain

Untitled #60, 1989
Gelatin silver print
19 7/8 x 23 7/8 inches
Courtesy Zabriskie Gallery, New York

Untitled (Three Arches) #38, 1989
Gelatin silver print
23 7/8 x 19 7/8 inches
Courtesy Zabriskie Gallery, New York

Collier Schorr
Born: 1963, New York, New York
Resides: Brooklyn, New York

Das Schloss (Horsti), 1994
C-print mounted on Plexiglas
70 x 49 ¼ inches
Collection Olivier Renaud-Clement

Cindy Sherman
Born: 1954, Glenridge, New Jersey
Resides: New York, New York

Untitled, 1981
C-print
24 x 48 inches
Collection Refco Group, Ltd., Chicago

Untitled, 1983
C-print
87 x 57 ½ inches
Collection Refco Group, Ltd., Chicago

Kenneth H. Shorr
Born: 1956, Goodyear, Arizona
Resides: Tucson, Arizona

Failure To Identify This Image As a Sign of Your
Pathology, 1990
Gelatin silver print
8 x 10 inches
Courtesy the artist

Untitled, 1992
Gelatin silver print
20 x 24 inches
Courtesy the artist

Untitled, 1992
From the series, Ornamentation for the
Marginalized
Gelatin silver print
8 x 10 inches
Courtesy the artist

Bio Fear, 1995
Gelatin silver print
10 x 8 inches
Courtesy the artist

Laurie Simmons
Born: 1949, Long Island, New York
Resides: New York, New York

The Music of Regret II, 1994
Black and white photograph
60 x 40 inches
Courtesy the artist and Metro Pictures, New
York

Sandy Skoglund
Born: 1946, Quincy, Massachusetts
Resides: New York, New York

Spirituality in the Flesh, 1992
Cibachrome
36 x 28 inches
Courtesy Janet Borden Inc., New York

The Cocktail Party, 1992
Cibachrome
36 x 28 inches
Courtesy Janet Borden Inc., New York

Hiroshi Sugimoto
Born: 1948, Tokyo, Japan
Resides: New York, New York

Elizabeth Taylor, 1994
Gelatin silver print
20 x 24 inches
Courtesy Sonnabend Gallery, New York

Queen Victoria, 1994
Gelatin silver print
20 x 24 inches
Courtesy Sonnabend Gallery, New York

Bernard Voïta
Born: Cully, Switzerland
Resides: Brussels, Belgium

Untitled, 1995
Gelatin silver print
9 x 9 ½ inches
Courtesy the artist and CRG Gallery, New York

Untitled, 1995
Gelatin silver print
9 x 9 ½ inches
Courtesy the artist and CRG Gallery, New York

Untitled, 1995
Gelatin silver print
9 x 9 ½ inches
Courtesy the artist and CRG Gallery, New York

Boyd Webb
Born: 1946, Christchurch, New Zealand
Resides: London, England

Diptych:
Left panel: Petri, 1994
Cibachrome print
30 x 60 inches

Right panel: In Vitro, 1994
Cibachrome print
30 x 60 inches
Courtesy Sonnabend Gallery, New York

© 1997 Independent Curators Incorporated
799 Broadway, Suite 205
New York, NY 10003
Tel: (212) 254-8200
Fax: (212) 477-4781
Email: ici@inch.com

Editorial consultants: Denise Bigio and
Kathryn Talalay

Art direction and design: Matsumoto Incorporated, NY

Lithography: Hull Printing, Co., Inc., CT

Edition of 2,500

Library of Congress Catalogue Card Number:
96-078945

ISBN: 0-916365-49-2